Forget M.E. Not

A Collection of Photography, Poetry, Artwork
and Short Stories

Association of Young people with ME

First published in the United Kingdom in 2015 by The Association of Young People with ME

Copyright © 2015 The Association of Young People with ME

The moral rights of the authors have been asserted by them in accordance with the Copyright, Designs and Patents Act 1993.

All rights reserved. Apart from any use permitted under UK copyright law, this publication my only be reproduced, stored or transmitted, in any form, or by any means, with prior permission in writing from the publishers and the author.

Edited by Katherine Langford and Jet Spero

Cover design by Katherine Langford, Jessica Anslow and Linda Ollerenshaw

AYME is a registered charity
Charity number 1082059

ISBN 978-1-326-17397-5

www.ayme.org.uk

Foreword

When I founded AYME in 1996, I was struck by the literary and artistic talents of our members. Even those very severely affected with the illness ME might manage a few words on a good day which would build up to a few poetic lines, often wishing their friends well. This led to a double page spread in the members' paper magazine, Cheers, called 'Wishing Well'.

This became a very popular part of the magazine and it's wonderful to see the same idea being brought up to date here in this book with brilliant sketches, superb short stories and wonderful photographs.

We have so many talented AYMErs in our organisation it was certainly right to showcase their work. This horrible illness causes overwhelming fatigue but, as this book depicts, talent cannot and will not be squashed or eradicated.

The writers, artists and photographers whose work is displayed here should rightly be very proud of their achievements. If this book also raises money for AYME and awareness of ME, then a triple whammy would have been achieved.

I wish you all well and thank the editors for giving me the opportunity to write a foreword for this excellent book.

Jill Moss

Contents

An Introduction to ME ... 6-8
Trapped in M.E. by Molly Mason 9
South of France Sketch by Linda Ollerenshaw 10-11
My Nemesis by Sam Jones .. 12-13
Sit With Me Skye by Amber Halstead 14-15
The Garden by Samantha Scott 16-17
Untitled by Chloe Thomas ... 17
Rhubarb by Abigail Carter .. 18
Wishes by Amie Shaw .. 19
What I Do and Don't Remember by Kate Coomby 20
Hope Transforms by Samantha Scott 21
Travel by Philippa Marshall 22
Sleeping Wolf Cubs by Anna Cann 22
Paws Up by Chloe Halstead 23
Freedom by Jade Smith .. 24
Through the Glass by Chloe Halstead 25-29
Django by Abigail Carter .. 30
Beryl by Amie Shaw ... 31
Unspoken by Eemaani Khalid 32-33
Ice Queen by Jade Smith .. 34
Rhubarb 2 by Abigail Carter 35
Tea for Two by Rebekah Morley 36
Blue Bake Sale for ME by Georgina Wasdall 37
Friends by Stephanie Davies 38-39
Having a Snack by Katie Stewart 40
Buoys on Herne Bay Beach by Anna Fitzgerald-Clark ... 41
Rolling Around on My Wheels with My Sister
 by Georgina Wasdall .. 42
Toby in Time by William Groom 43-44

Windmill after the Rain by Anna Fitzgerald-Clark........... 45
Alfie by Brittany Gordon..46
School Before Dawn by Eemaani Khalid........................47
Bubble the Beaver by Chloe Halstead...........................48
Winter Pansies by Rebekah Morley................................49
Watching, Waiting by Katie Stewart...............................50
Prison by Zack Smith..51
Tears of the Earth by Emily Forward............................. 52
Fishing Boat in Whitstable Harbour
 by Anna Fitzgerald-Clark..53
Waterfall of Flowers by Emily Forward..........................54
A Boy and a Girl by Kate Coomby............................ 55-58
Frosted by Amie Shaw..59
Journey by Philippa Marshall..60
Down the Promenade by Katie Stewart........................61
Sleeping Girl by Anna Cann..62
The Gift by Eemaani Khalid...63
Ripples by Emily Forward.. 64
Chloé by Brittany Gordon..65
Hello Caterpilly by Brittany Gordon...............................66
Lego Adventure by William Groom........................ 67-68
Sleepy Skye by Amber Halstead...................................69
Steam Punk by Jade Smith..70
Doctor Doctor... by Stephanie Davies.....................71-72
Soapbox on Chronic Fatigue Syndrome/Myalgic
 Encephalopathy by Georgina Wasdall.............. 73-74

An Introduction to ME

What is ME?
ME stands for Myalgic Encephalopathy. It is a long-term debilitating condition which sadly for some can last for years. The main symptom is overwhelming fatigue. This is not the same as the normal tiredness healthy people experience. It is not relieved by rest or sleep. For those most severely affected even seemingly small tasks like brushing your teeth or sitting up in bed for five minutes can be utterly exhausting. This leads to some children and young people living with ME ending up housebound and even bedbound. Other symptoms include nausea, sleep disturbance, dizziness, muscle and joint pain, headaches, brain fog, sensitivity to light, sound and touch to name just a few. In extreme cases this results in lying in a darkened room perhaps wearing an eye-mask and earplugs; sometimes unable to even hug their family because of the pain it causes. It can affect people of any ethnicity and social background and all ages, even children as young as three.

What causes ME?
To date there is insufficient information about the cause of ME. There are many theories and much speculation. What we do know is that, until the much needed research can give us the answer, ME is the main cause of long term school absence affecting 1/100 children age 11-16 years. Many of them are unable to access the specialist care that is needed to improve their prognosis.

How do you recover from ME?
There is no cure for ME, no diagnostic test or medication available except to help with the management of symptoms such as nausea, pain and sleep disturbance. As ME affects different people in different ways it is difficult to prescribe a 'one size fits all' approach to recovery. Generally someone with ME is helped to work out their "baseline". This is the amount of activity achievable every day for several weeks without an increase in symptoms. Once established a gradual increase in activity is introduced working towards (for 50-90% of patients) recovery. Prognosis for children and young people is far better than for adults, especially if there is prompt diagnosis and the correct support and guidance is provided from therapists and doctors who have knowledge, skills and experience of working with ME/CFS (Chronic Fatigue Syndrome).

What is AYME?
The Association of Young People with ME (AYME pronounced 'aim') is a charity for people aged 26 and under who have ME. We run a helpline, a website, an online magazine and members' area with a secure and moderated message board. We also provide support and information to parents and carers via our Parents & Carers Group and Supporters are able to join as well and receive news, research and fundraising updates. An important part of AYME's work is to help those families in crisis unable to access care, management advice and, for some, a diagnosis. Most important is the little word 'of', in the 'Association of Young People with ME'. Many of AYME's direct services are run by amazing young people who have ME themselves who choose to

dedicate some of their precious energy to supporting others – like the members who have created this book. Without Katherine and others like her AYME would not exist and continue to thrive.

I know someone with ME, how can I be supportive?
Simply by learning about the condition and trying to understand you are making a positive start. Even simple tasks can be difficult so offer to help by fetching things or getting drinks when needed. Try to make sure they are comfortable and there is not too much noise or activity as this can be very tiring. Remember they may not look ill. ME/CFS is not like a broken leg which you can see. You can keep an eye out for signs like their face becoming pale which indicates they are getting over tired and need to rest. People with ME/CFS often become isolated and lose all their friends because they are not well enough to stay in touch. Reading long letters might be difficult, but receiving short notes, cards and text messages on a regular basis can be really appreciated. Your ongoing support and friendship can and will make a difference.

For more information, including details of our helpline, please visit AYME's website (www.ayme.org.uk).

Trapped in M.E.

People like me bottle things up...
Too scared to tell people because they have had enough...
We're trapped in a box, can't find a way out...
All we can do is just scream and shout...
We feel under pressure, 'cause we might float away...
We do have a point at the end of the day...
It's us who feels it, it won't go away...
Why do we have to answer these silly questions...
I'm not a website, so here's a suggestion!
Stop asking me this... Stop asking me that!
'Cause to be honest... You're stamping me flat...
You say you ask me... you need to know how I feel...
But I just don't know... I just know that it's real...
If you feel like this...
You're not on your own...
Just read this poem... You're never alone!

By Molly Mason

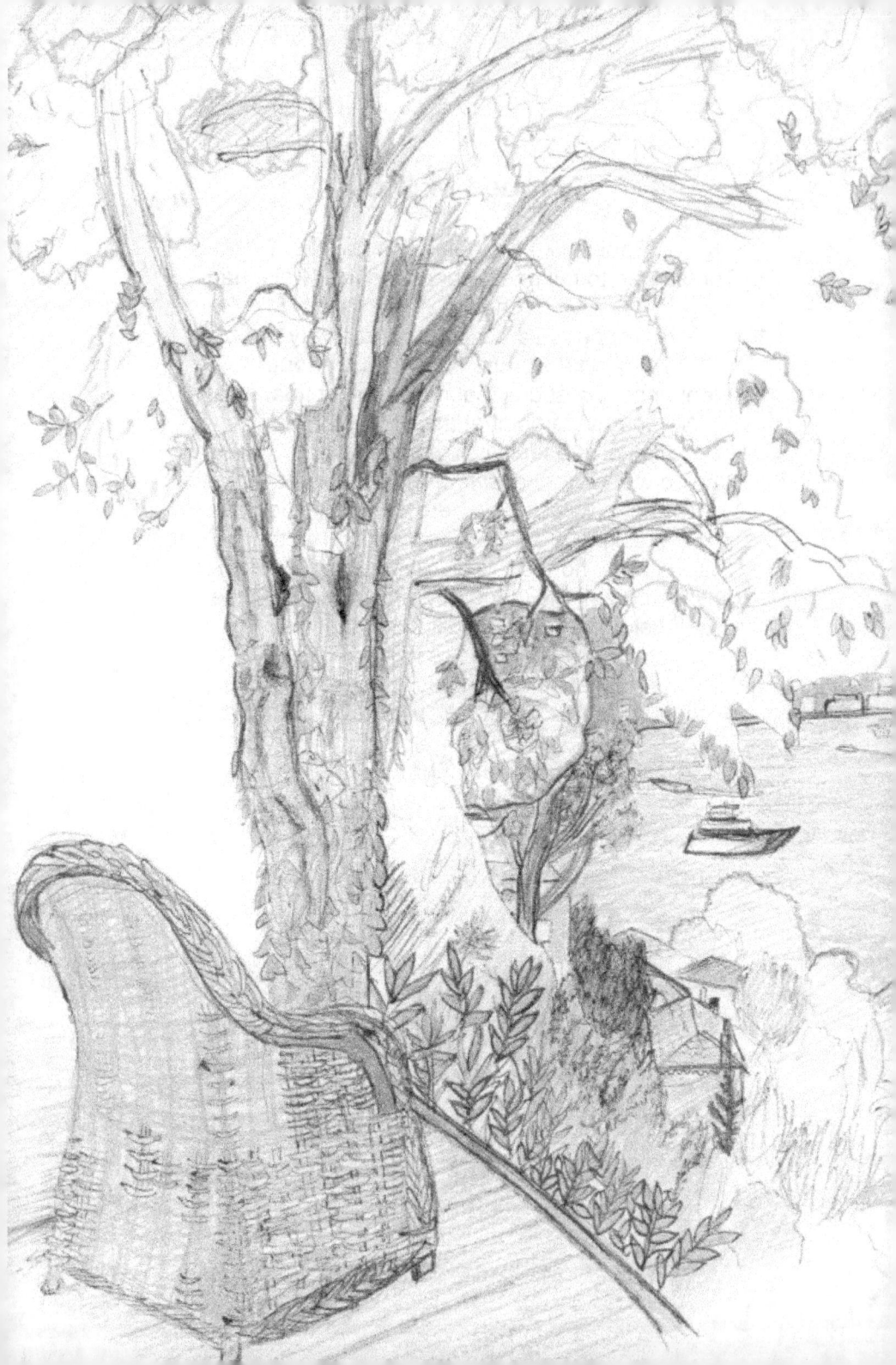

South of France Sketch

This is a sketch of the view from a villa I stayed at in the South of France (the buildings in the distance across the sea are in Cannes). It was the first time in four years that I had been well enough to go on holiday, so it was a special week. Looking at this sketch again is more of a reminder of how I felt during that time than any of the photos I took as I remember spending a lot of time taking in and appreciating every aspect of the view as part of the drawing process. It allowed me to make the most of where I was and I really enjoyed the holiday.

By Linda Ollerenshaw

My Nemesis

One minute I was running
The next, I was down.
What has happened here I thought?
From that day on, my body felt like a lazy lump.
What had changed? Everything.
Why could I not get around?

Four wheels were mentioned, great I thought.
My vision of a motorised buggy
Shattered in a moment.
Even though it looked like fun,
My part in it was not at all.
I knew I was not going to like it.
From that moment on...
It was my nemesis!

My little legs too tired to run on.
My nemesis there, waiting to help me.
It gives me a place to sit and move around
To keep me from lying on the ground.
My head was down.
Why could I not look around?
Was it the fact that I was sitting in my nemesis
Or was it just me?

My first trip I was dreading,
All those people looking down.
What were they thinking I thought?
As I passed in my nemesis.
Why is it so embarrassing I asked myself?
Was it that the nemesis was winning
Getting me down?

But the nemesis was not going to win.
Next time, I tried looking around.
I noticed no one was staring.
They were smiling
As I sat in my nemesis.

Next I showed the nemesis to my friends.
Guess what; they loved it and so do I.
From that day on
I started working with
And not against my nemesis.

Finally, I began to see
My nemesis as a friend not foe.
I feel happy to be in it.
It gives me strength when I feel weak.
Head held high
I am breaking free.

By Sam Jones

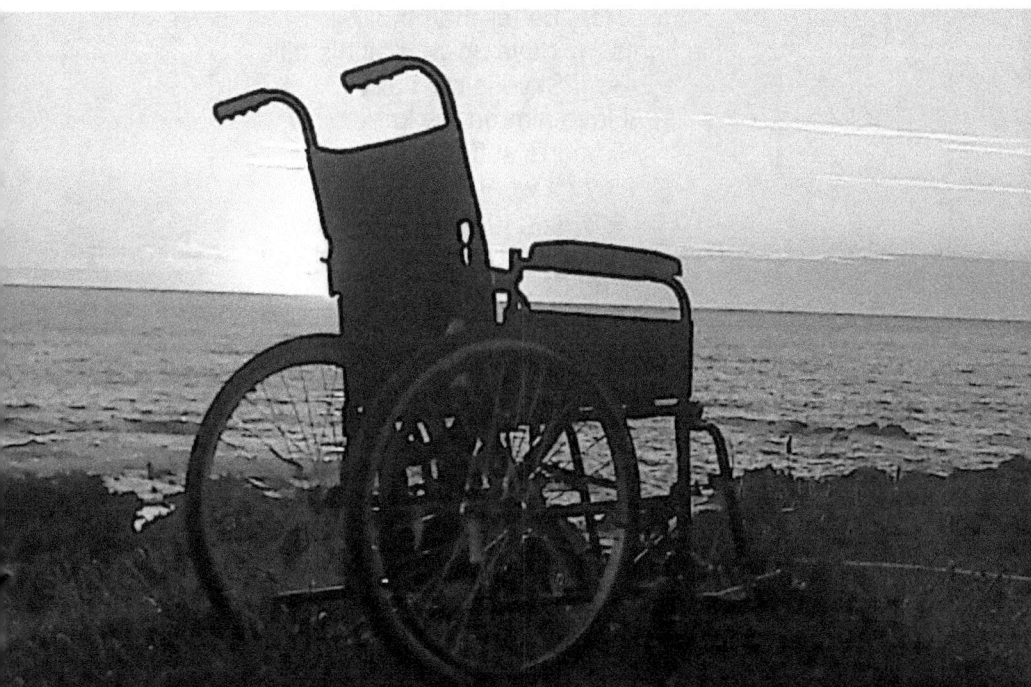

Sit With Me Skye

Once there was a little cat called Skye
And he was mine
And he was mine
I chose him for his perfect pink nose
His fur as black as coal,
His chest and paws as white as snow
Will you come and sit with me Skye?
Sit on my knee and close your eyes.
Will you come and sit with me Skye
Sit with me Skye?
I chose my Skye when I was four years old
He was so bold
It's a special story to be told.
Me and Skye we share a special bond
A strong connection
Skye is perfection

Skye has been my comfort while I'm ill
He's better than a pill
He lights my days up with all his trills
And Skye is my baby
I love him on my knee
His purrs soft to my ear
I love it when he's near
I'd do anything to make Skye purr
I'd tickle his tummy and stroke his fur
And Skye is my baby,
I want him on my knee.
Will you come and sit with me Skye,
Sit on my knee and close your eyes,
Will you come and sit with me Skye
Sit with me Skye?

Once there was a little cat called Skye
And he was mine
And he was mine
And when Skye has finished off his tea
He made me so happy
He came and sat upon my knee.

By Amber Halstead

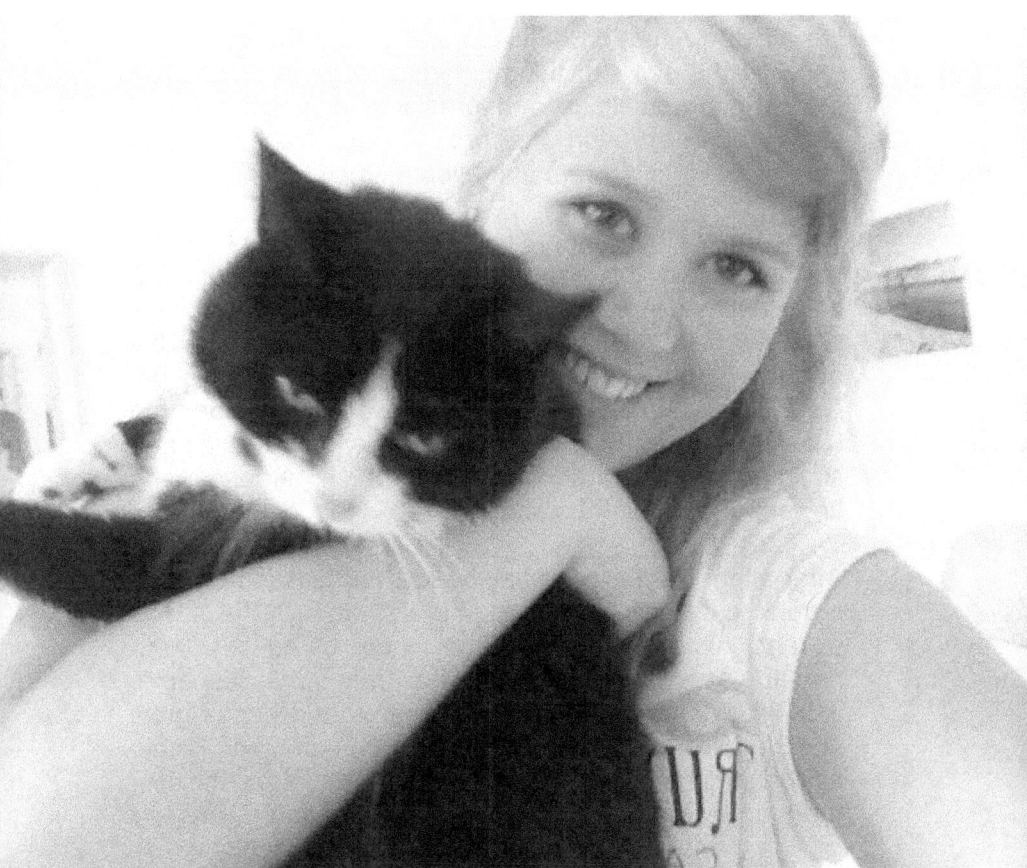

The Garden

The boy had a garden all of his own. A little patch of dirt outside his front door. It was just for him and he alone tended to it. Every night, when it got dark, he would visit there under a cloak of stars. He would sit there and dream of all the things he could plant and nurture in his little patch. It didn't seem much, but it was his and he loved it.

He planted seeds of all kinds and so did the birds. He watered the soil and things started to grow. It was like magic; so marvellous and precious to watch the tiny seeds burst through the ground and transform into beautiful plants, flowers and even a small tree!

As he grew older so did his garden. And just like life, he had a battle on his hands. He fought against slugs and cats that would sneak in and try to eat or dig up his precious plants. He worked hard in his garden, one day at a time. Some of the plants died or got eaten by bugs. Over time, he matured into an adult and the garden did too. A giant tree that reached to the sky stood proud and strong in the centre of his little patch, amongst the flowers and the shrubs and the weeds that ever-grew.

After all these years the tiny seeds had blossomed, with regular care and encouragement. Some of the seeds weren't expected but the boy had cared for them nonetheless, curious to see what they would become. Just like his garden, the boy's dreams and hopes grew and evolved. Sometimes, the unexpected would happen, the paths weren't always straight. Nevertheless, the journey was beautiful. Just like his garden, the boy (now a man) had a life full of wonder and beauty.

Sometimes, you have to look a little harder, beyond the weeds and the slugs, to see the amazing tree that is growing tall and strong. Don't forget, hopes and dreams need watering too.

By Samantha Scott

Untitled
By Chloe Thomas

Rhubarb
By Abigail Carter

Wishes
By Amie Shaw

What I Do and Don't Remember

I don't remember what it's like to not have the people
you thought were your friends turn against you,
Or to have trust in everyone because you don't think
they'll ever let you down.
I don't remember what it's like to not feel this exhausted
every day,
So that I want to be physically sick but can't.
I don't remember what it's like to not have an illness that
people accuse me of making up,
Just because they can't see it,
(Because we all know that seeing is believing).

I do remember that this has made me realise who I can
count on,
Who really matters.
I do remember that it gave me education because I had
nothing else,
And that's one of the greatest gifts of all.
I do remember what it felt like not to be a prisoner in
my own body
And I do remember the stories of the lucky ones who
broke free
(Hope is everything).

By Kate Coomby

Hope Transforms
By Samantha Scott

Travel

I heard of travel
Through the seasons, one long trek
From night to new dawns

By Philippa Marshall

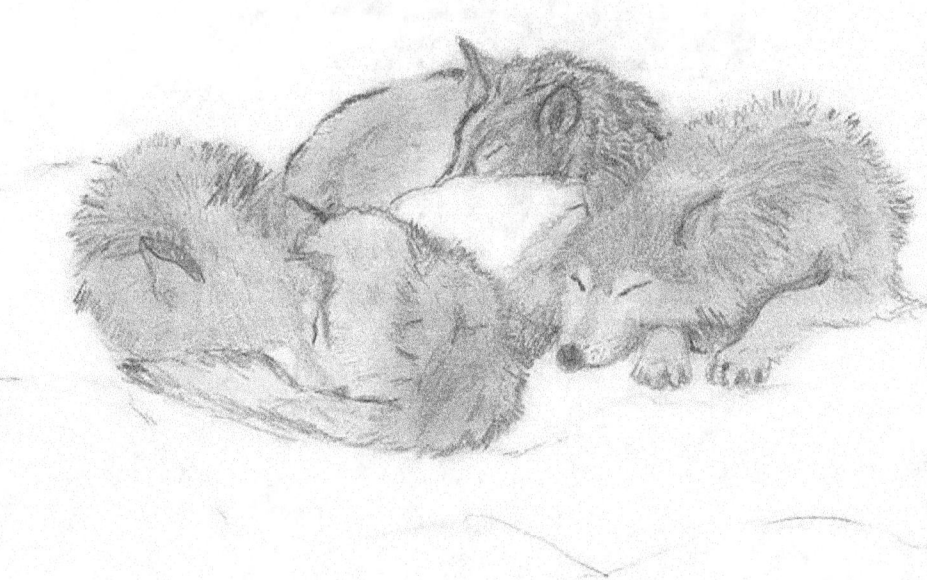

Sleeping Wolf Cubs
By Anna Cann

Paws Up
By Chloe Halstead

Freedom
By Jade Smith

Through the Glass

The glass was always there. A huge barrier separating Sophia from the outside world. Sometimes she held her hand up to touch the blueness and freedom of the sky, but her hand always touched the cold glass panes.

"Stop gawping through the window," her mother snapped. "Come and help me clean the floors."

Sophia sighed. Her hands were raw from cleaning.

"Don't sigh like that Sophia, do you have any idea how many germs can accumulate in one day? We need to protect you."

"Maybe after that I can go and play with the kids across the road." She gazed longingly down at them. She'd never met them, never been allowed out but by watching them she knew their names, their characters and that Tommy was her favourite. He always seemed the kindest, helping the others if they fell over but also leading the best games, skateboard races and swinging from the rope swing. She pictured his smile whenever she felt sad and it always cheered her up.

Her mother laughed sharply smashing her thoughts. "Go out. Play with them. I don't think so Sophia, you almost died as a baby remember. The doctor said to be careful. Why do you think I keep you in here like this. To be cruel?"

Sophia blinked the start of tears away. She still had the scar from the life saving operation when she was born. A cold white line like the dividing line between her and a proper life. She understood, sort of, but surely playing with some friends wouldn't be bad. And the doctor had only said be careful in the first few years. Her mum had got so used to it she felt like she lived in a

bubble and the smell of antiseptic and cleaning products made her sick.

She gave one final glance out of the window and slumped off to join her Mum.

"I'm just going out to get some fresh fruit and veg."
Sophia glanced up as her mother spoke.

"I won't be too long. Just make sure you don't go into the garden. There's a few mole hills and I don't want you tripping over and breaking your neck."

Sophia just nodded and waved as her Mum left. She switched the TV on and tried to concentrate on a nature documentary. A loud grumbling of an engine coughed into the air. Sophia frowned. Since when did that appear on a documentary about under the sea? She muted it and the sound continued.

In a second she was at the window staring out. Tommy and the other children were out in the street. Her eyes widened. Tommy was sitting atop the most amazing quad bike with painted silver and blue fire flames licking over it. Tommy skidded around on the Quad and the other kids cheered. Sophia's heart ached. She wished she could do that, and let others think she was cool for once. Instead of always being the girl at the window.

In that second her mind was made up. She grabbed her coat and trainers and ran outside.

"Hi," she said with a gulp before she could change her mind.

The other kids ignored her, they probably couldn't hear over the Quad engine. Tommy glanced up. His smile faltered as he laid eyes on Sophia. Then he grinned, "Hi Sophia, check out my quad bike. My Dad got it me for my birthday!"

Sophia's heart gave a little flip. He knew her name, "It's amazing," she said.

Tommy hopped off it, "Want a go?"

One of the kids laughed, "Scaredy cat Sophia. She wouldn't ride a bike without crying. Her mum won't let her. Ooh."

Sophia scowled at him.

Tommy did too, "Says the person who cried on the spinning teacups. She can do what she wants."

The boy scowled and stormed off.

Sophia smiled gratefully at Tommy who pointed at the quad bike.

"So..." He said.

Sophia grinned. Her mother would probably kill her if she found out. Of course she didn't need to find out.

"We won't tell your Mum," Tommy said, "Right guys."

Everyone nodded. Sophia took a deep breath and wrapped her hands around the rubber handles. It felt real. It felt scary. It felt good.

Tommy quickly showed her how to control it and stepped back. His eyes sparkled in the summer light, "Good luck."

"Thanks."

She held the accelerator down and lurched off. It felt incredible. The world whipping fast. She held the accelerator down more. Now the world was hurtling past in a dizzying blur. Ok too fast. Way too fast. She grabbed for the brake and felt two of the wheels leave the ground. A huge force sucked at her trying to peel her off and she saw the steps to the pond coming up. It was too late. She hurtled down them, her head shaking like a blender. The edge of the pond rose up. She couldn't stop. She slammed the brakes on harder and this time

all four wheels left the ground as it spun round. She found herself shooting through the air, her screaming ripping through the trees. Then the pond opened its mouth to catch her. She sank under and fought to the surface gagging and spitting, flailing helplessly. Her Mum had been too scared to let her learn to swim. She kicked her legs out and felt them strike the bottom. Dirty pond water dragged on her clothes as she stood up. The water bulged around her knees. She looked up as Tommy hurtled down the steps followed by the rest of his friends. She braced herself waiting for the mocking laughter, the cruel comments. She prepared herself, ready to run. Tommy grabbed her arm and helped her up, "Whoah, Sophia are you alright?"

Sophia nodded shakily.

Tommy knocked a lily pad off her head laughing. But it wasn't in a cruel way. "That...was...AWESOME!" I've never seen anyone drive like that. You have to show me what you did. Seriously. It was amazing!"

Sophia grinned, "Seriously. Even though I'm covered in pond scum?"

Tommy laughed and put the lily pad on her head, "I now crown you Queen Sophia of the Lily Pad Pond."

Sophia gasped, "Well you can be King Tommy of Pond Scum," she ran at him with a handful of the weed and Tommy ran shrieking up the hill. She was about to throw it when she spotted her Mum's car driving down the hill. She stopped in horror, "Oh no, if Mum sees me like this she'll never let me leave the house again." They ducked behind the trees as the car went by.

Tommy grabbed her arm, "Don't worry, I know a shortcut, follow me. We'll be in your house before she's even parked."

Sophia dashed with Tommy around the trees and they stumbled into her back garden. Shivering with

excitement Sophia scrambled through the window and Tommy followed.

"Grab a chess board and I'll get in my pyjamas. We can pretend we've been playing."

Tommy did as she said and grabbed the board as Sophia hurtled up the stairs. In seconds she was in her pyjamas and stood still staring at her pond soaked hair in the bathroom mirror. Hurriedly she ran her head under the tap, threw a towel around her head and fled down the stairs almost flying again. She skidded next to Tommy just as the front door opened and her Mum came through bundled with armfuls of vegetables. She smiled at them both, "Oh good girl you've got ready for bed early."

Sophia and Tommy grinned at each other as her Mum wandered into the kitchen. He whispered in her ear, "You know my Dad's got a helicopter. Fancy a go?"

By Chloe Halstead

Django
By Abigail Carter

Beryl
By Amie Shaw

Unspoken

I want to tell you about
the dust I wrote my name in.
But I don't.
Or the tents I built behind empty wardrobe doors.
I want you to read the stories,
etched into the soft skin folded across the palm of my hand.
And I wish you knew
about the fairytales I tried so hard to believe in,
and the nights I cried.
Rain water soaked my white canvas pumps:
the ones with the aliens on.
You weren't there to clean them.
The bus was cold.
I searched for you in the car park,
for your warmth. For a hug.

Maybe I should tell you
about the butterflies that hung by the door.
But I don't.
I wanted you there to put up blackout blinds.
Or curtains.
It didn't matter which.
I wish I could tell you about
the way the darkness grabbed me.
Or the feeling of breathlessness beneath my feet.
Sometimes I wonder if you knew
how deeply I loved you.

I didn't.

I wish I was brave enough to show you
the scars.
And to tell you how I got them.
But I'm not.
I want you to run your fingers across
the crevice of my heart.
Stop it bruising my beaten chest.
Leaves dropped from the boughs of trees
like the hair from my head.
I longed for you to brush it.

And even though I've turned eighteen,
I still need you.
I know that you know that.

I didn't.

By Eemaani Khalid

Ice Queen
By Jade Smith

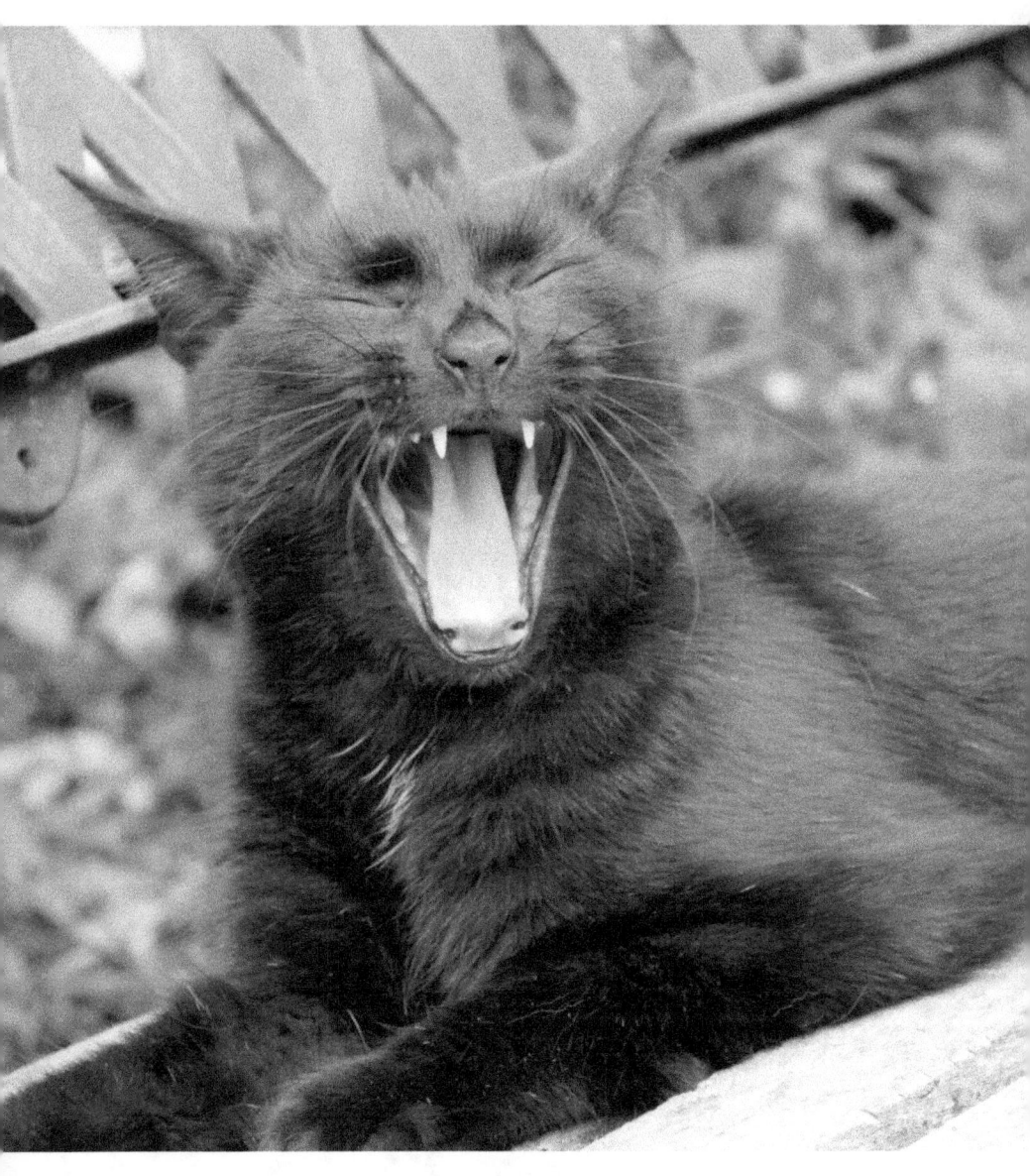

Rhubarb 2
Abigail Carter

Tea for Two

"Come in!" says she and I, to you
"Come and join our tea for two."
"But," says you, to her and me
"then we'll be having tea for three."
"Oh" says her, to me and you
"is that worse than tea for two?
Tea for two is how it's done
can tea for three be just as fun?"
"Well" says I, to you and her
"I must confess I do concur
that tea for three is quite unheard,
in fact it sounds almost absurd!
But here we have this extra chair
which has no purpose holding air."
"Indeed" says she, to you and me
"So what say you to tea for three?"
"Tea for three sounds just as good
and so I think we really should,"
Announces you to her and me
"Let's sit down and drink us three!"
And so we sit, me, her, and you
And instead of having tea for two
We sit and drink tea for three
She and I, and you and me.

By Rebekah Morley

Blue Bake Sale for ME
By Georgina Wasdall

Friends

Things were going great,
Things were looking up.
Little did I know my bad fate,
What was about to happen.
What it was going to create,
From the inner me.
What it was going to demonstrate,
From the real you.

It's crushed my life,
It's taken my dreams.
It's sharp like a knife,
It stabs you in every way.
It leaves no delight,
All you can do is lay in bed,
You don't even have to wait till night,
Till the darkness strikes.

But it's not just the fatigue,
No that's not all.
Would you believe,
It's much, much more,
It's the pain you can't relieve,
No pills to take away.
It's your old life you have to leave,
Simple tasks become giant.

And then when I need you most,
When you're supposed to be there.
You turn into a ghost,
Nowhere to be seen.
Tho' haunting me close,
To my heart and my brain.
And no one knows,
How much it hurts.

To be on your own,
Throughout the day,
You become like a clone,
Empty and lonely,
If only you had known,
How much it hurts,
When you postpone,
Or don't even bother to pick up the phone.

How much I try,
And be there for you,
When things go awry,
I'll try to help,
When you cry,
I try to collect your tears.

So where have I gone wrong?
Why have you left me?
You're moving along,
Moving on,
This is no song,
My life has changed,
I'm not strong,
I need some friends.....

By Stephanie Davies

Having a Snack
By Katie Stewart

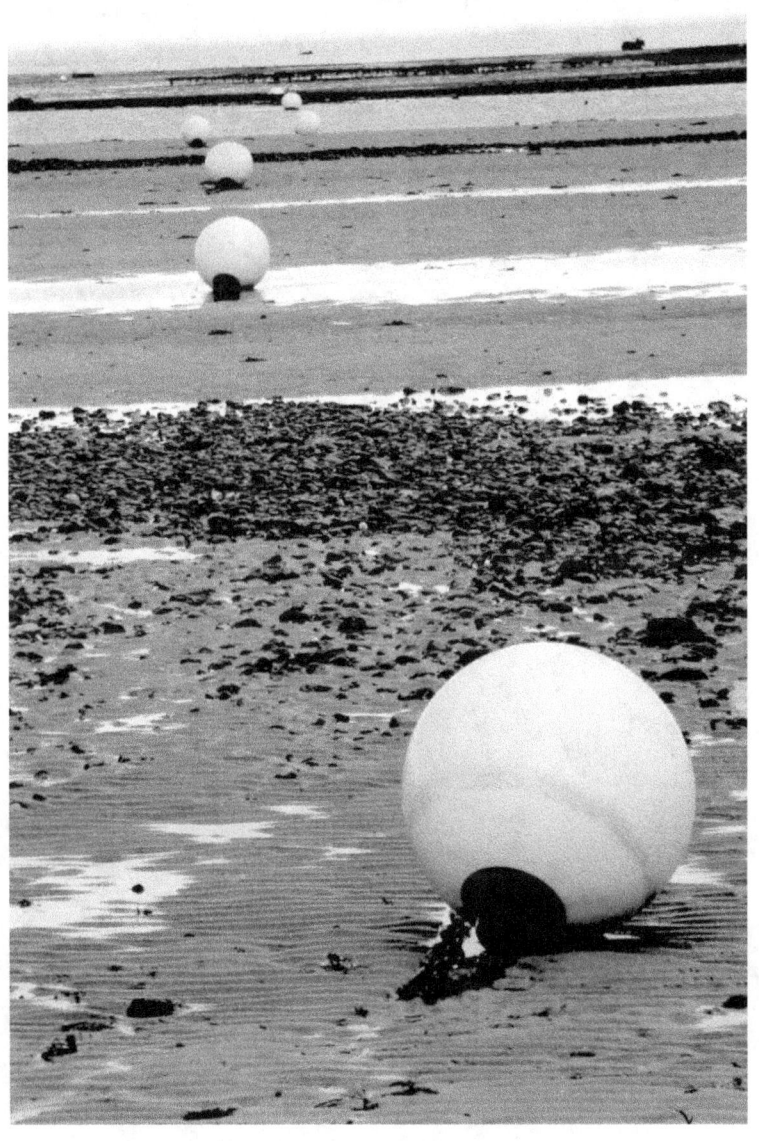

Buoys on Herne Bay Beach
By Anna Fitzgerald-Clark

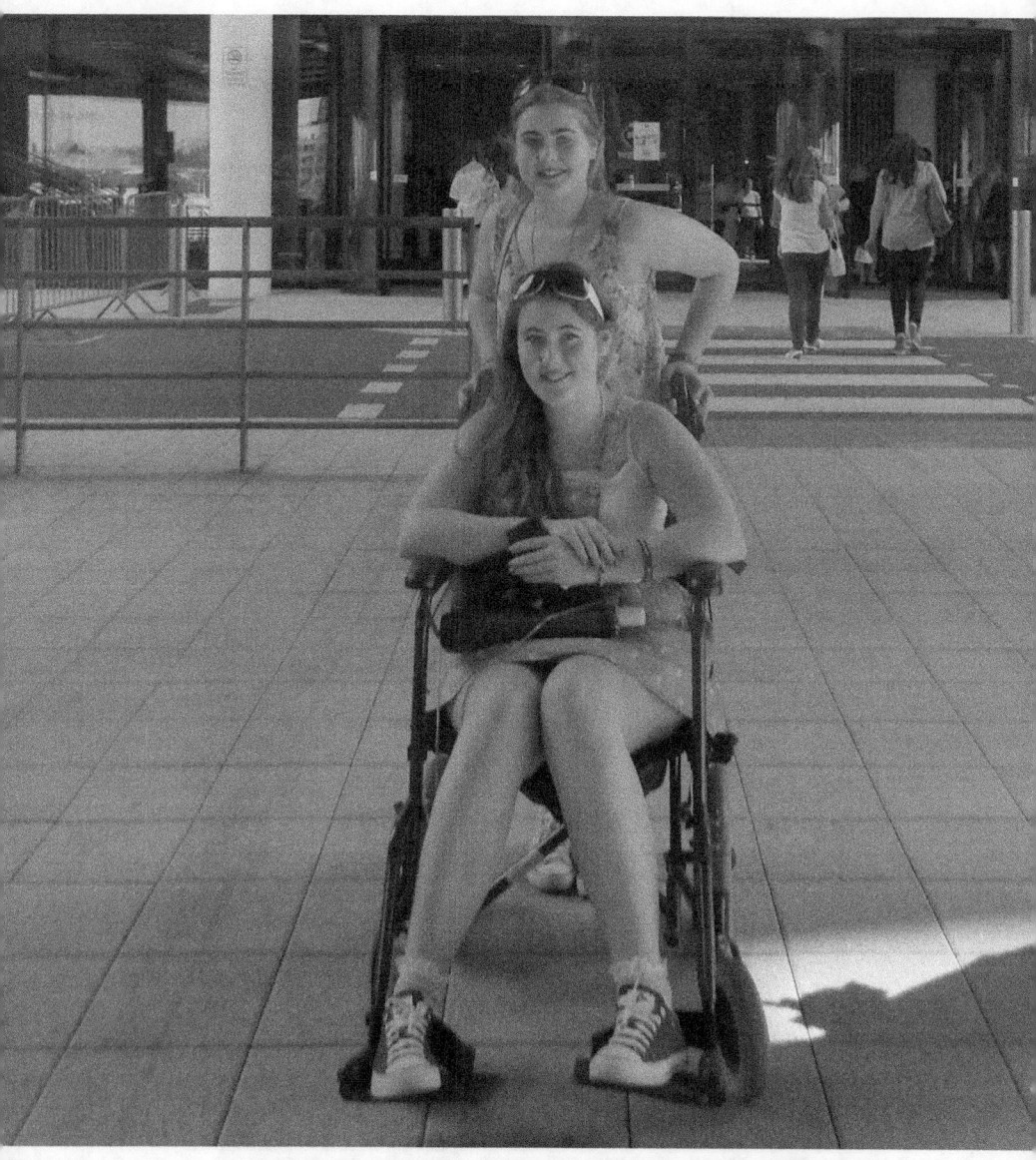

Rolling Around on My Wheels with My Sister
By Georgina Wasdall

Toby in Time

Toby was a happy boy, and very inventive. Especially in his dreams, almost too inventive... Thoughts came fast. A volcano of words. His brain was like a machine. One cog turned the next, like an automated toy on turbo power. But in his dreams his imagination could turn into nightmares. His creations might not work, or worst of all he could get trapped or stuck. The only downside of his talent.

Mum said that she needed some medicine, so Toby offered to go. Just as he was about to walk into the chemist, something shiny caught his eye. He walked round the corner. What could it be? Something that looked like, like... nothing he'd ever seen before! Forget the medicine. Wow! He immediately rode it home. A huge scooter, huge wheels! Amazing blue stripes down the sides.

The next day Toby had forgotten all about the scooter. He was bored so he went on his computer to kill some time. Time! The word flashed in Toby's mind like a billboard in Las Vegas. Maybe it was a time machine! The ideas in his mind started to whirr around like they were a tornado. The notion that he might have found a time travelling scooter made his heart beat as fast as engine pistons.

He stood on it. So many levers. Complicated. Hmm. Numbers. Dates. He set it to 1/1/4,000,000BC. Off down the road. Left foot pushing hard on the tarmac. Speedometer, 12mph... BANG! Huge blue light. Dinosaurs towering over. It was amazing! Terrifying, but amazing.

'I know,' Toby said to himself, and with ideas going off in his mind like fireworks, he entered the date 2/3/2007AD. He remembered this day clearly. Charlie

Crockett had squashed his sandwiches with his big, meaty fist at lunch time. Toby faced the scooter down a mountain – 12mph – BANG! He was watching himself eating lunch. Charlie approached. As he reached past Toby, the real Toby pulled him back by the collar, and the six year old Toby grabbed his lunch and moved tables.

Toby watched Charlie Crockett go and annoy someone else, then felt his inventive mind wake up again. What would it be like to go to the future? 1/1/2100AD. 12mph. BANG! Light! Woah...not like he imagined. No flying cars. Not as futuristic as he had thought. He had imagined all sorts of robots and machines. He hung around for a while, watching. The money was cool, it had a picture of a book on it and they were called Bookes and there were 10 Booketts in a Booke, and 100 Bookes in a Novelle. The rest was BORING!!

He'd had enough. Time to go home. 22/1/2014AD. 11mph. No bang. Wait... what? Did it need batteries or something? He tried again. He couldn't reach 12mph. He started panicking. He was alone in a future years ahead of his time. He felt desperate. He knew no-one. Would he be able to sort it out? Could he mend it? It was all like his nightmares, stuck in time...

By William Groom

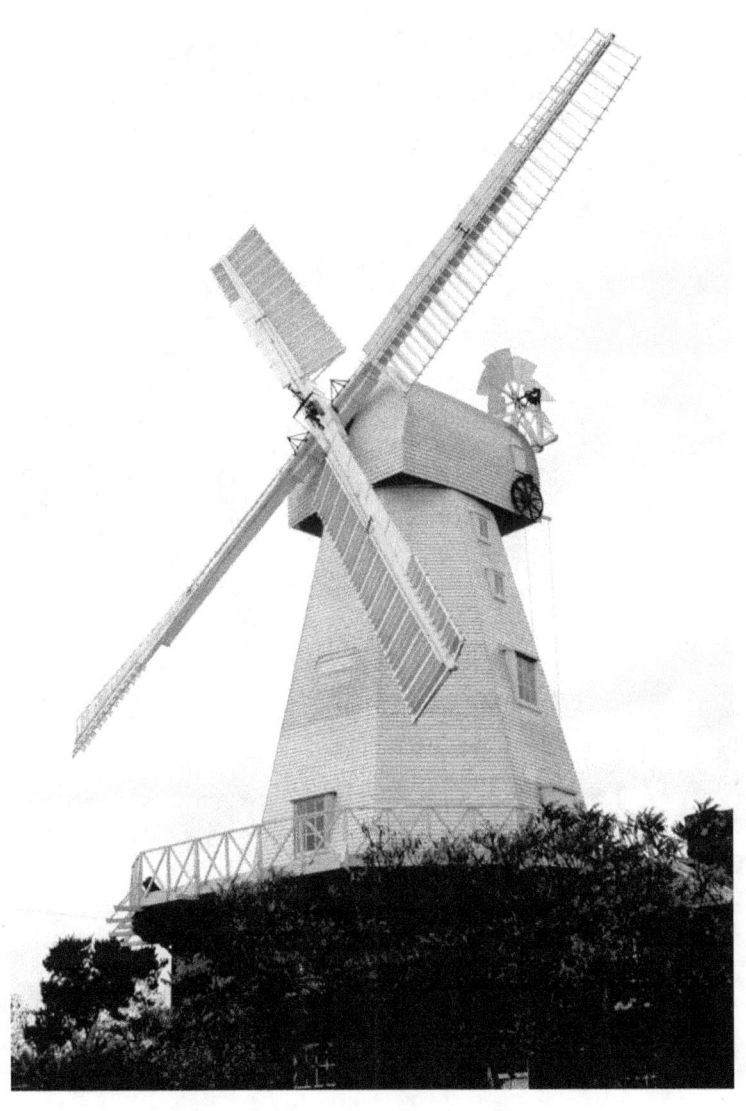

Windmill after the Rain
By Anna Fitzgerald-Clark

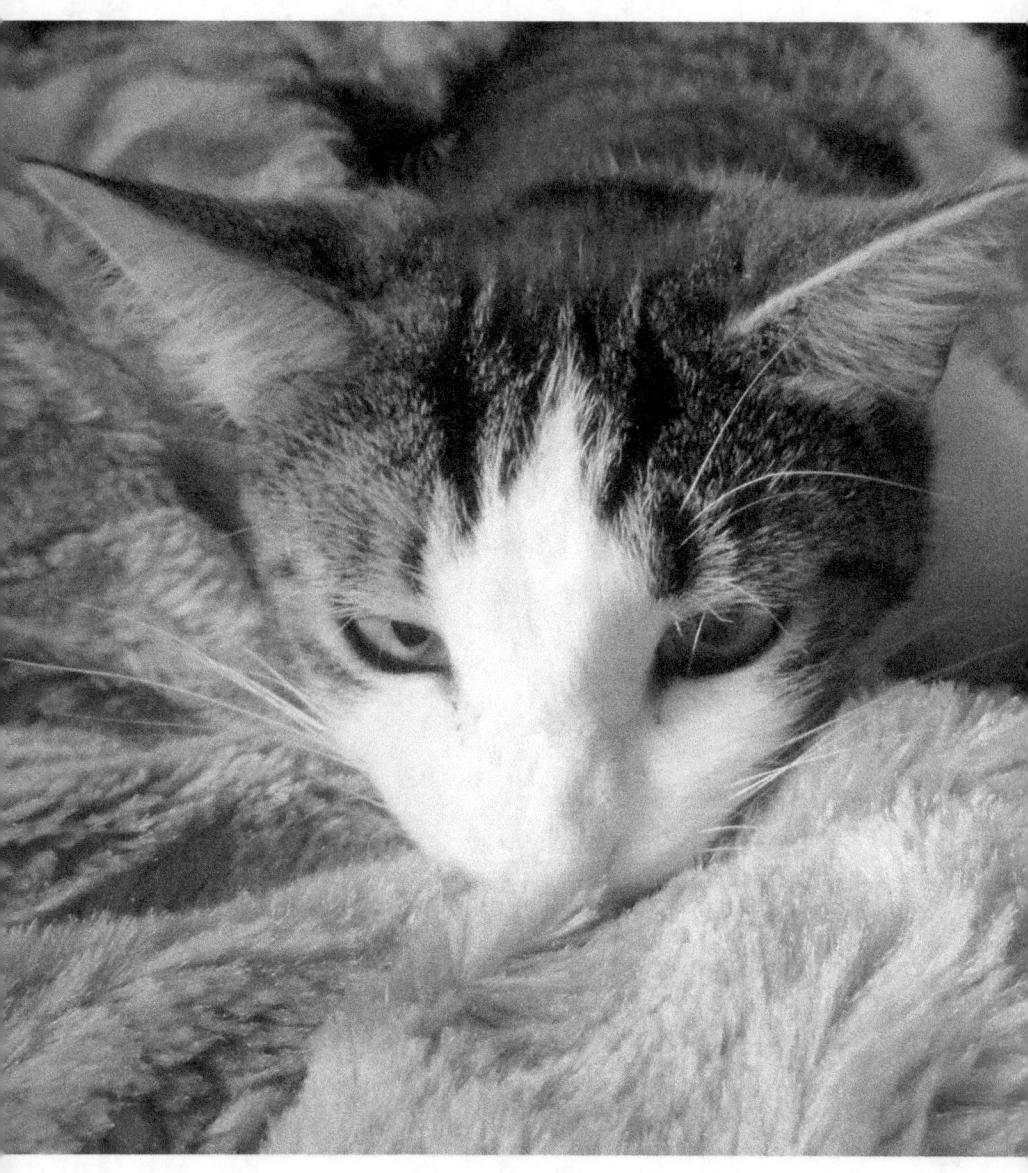

Alfie
By Brittany Gordon

School Before Dawn

Back alley, darkness blinding.
Feet slapping cobbles.
The cold:
silent monster biting.

Street light, barely breathing.
Heart hitting lampposts.
The shadows:
black beasts breeding.

Side road, world unfurling.
Toes kicking curb side.
The bridge:
soft stones deserting.

High street, souls evading.
Hands scratching signposts.
The dark:
deep crevice gaping.

Bus stop, town clock ticking.
Lungs snatching poison.
The journey:
alone; decaying.

By Eemaani Khalid

Bubble the Beaver
By Chloe Halstead

Winter Pansies
By Rebekah Morley

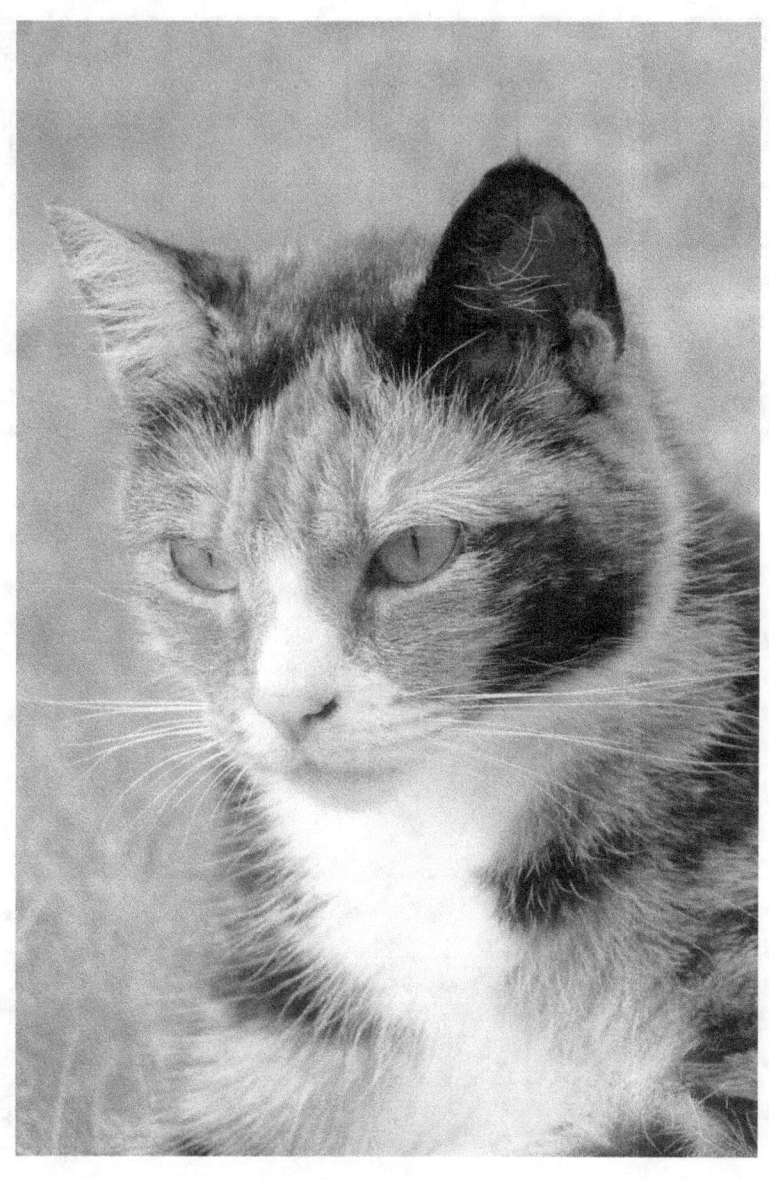

Watching, Waiting
By Katie Stewart

Prison

I'm in a prison
An invisible prison
There is a guard there
Who I can't see, but I know is there
It's in charge of my energy
It's in charge of how tired I am

Sometimes it lets me out and have my energy back
It can be for a short time or a long time
It lets me have my freedom back
But it makes me go back in
It always does

I am not the only one in an invisible prison
There are lots of people all over the World in an invisible prison

Be warned prison we are fighting back
We will have our great escape!

By Zack Smith

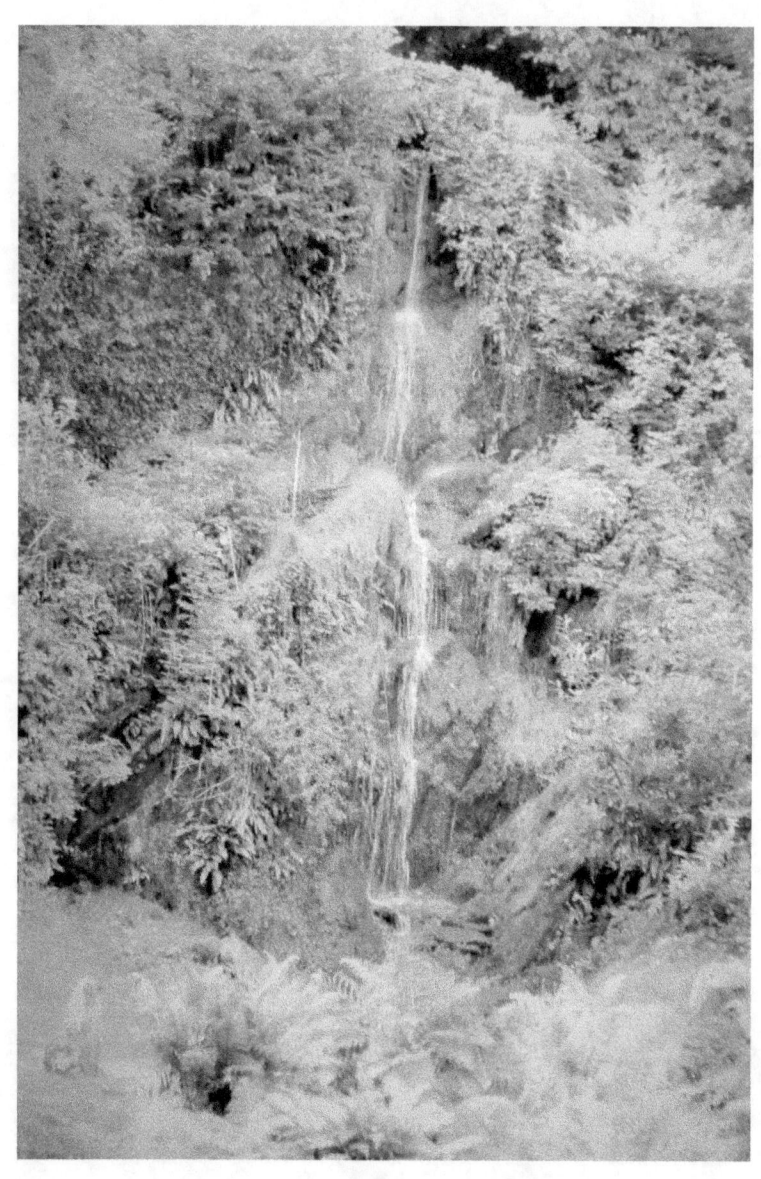

Tears of the Earth
By Emily Forward

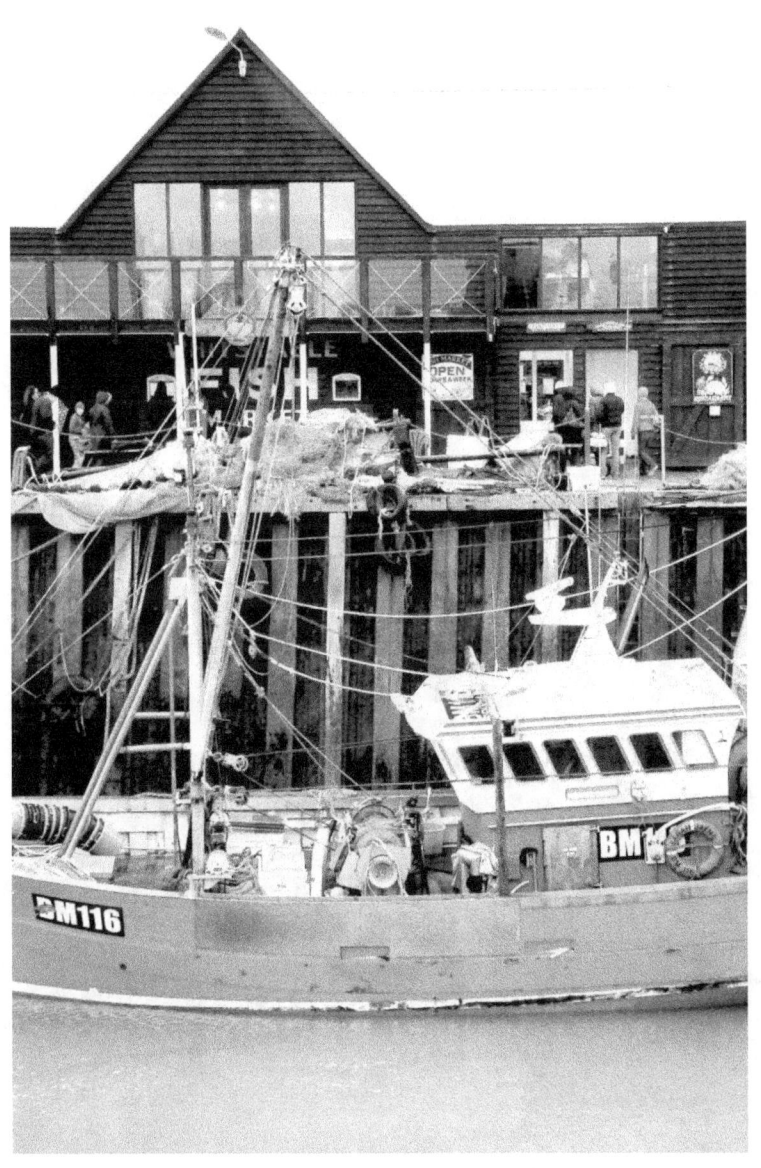

Fishing Boat in Whitstable Harbour
By Anna Fitzgerald-Clark

Waterfall of Flowers
By Emily Forward

A Boy and a Girl

A boy and a girl sit in a room. She has something to tell him and is struggling to find the words.

"I'm leaving."

She has chosen simply because she cannot, the girl realises, glamorise the subject in any way.

"I don't understand," says the boy. "Leaving to go where?"

Her heart aches with the pain of trying to tell him. Yet what she would really like to say is even harder than this.

"Paris. I'm moving to Paris."

He inhales sharply, "Oh."

They are silent for too long before the boy speaks.

"Well, I hope your life there is everything you want it to be," he tells the girl calmly. Really he would like to scream at her, tell her not to go. But he no longer has that right.

The girl frowns.

"That's all you have to say to me?" She is hurt. Is that what the boy wanted?

"I have to go," he replies. The boy stands and turns to go so he won't see the tears in her eyes, nor she his.

The girl stands in her room that night, with two piles on the bed in front of her. 'Keep' and 'Discard'. Sorting through a drawer she finds an old necklace (Discard), her favourite teddy from when she was small (Keep) and a picture of her and the boy (?). They are smiling cheekily up at the camera and he has his arm draped

around her shoulders in the picture surrounded by an oak frame. She strokes it for a moment, deciding, and eventually adds it to the chosen pile.

The boy stands on top of the hill where they used to sit. Sometimes he and the girl would bring food and picnic in the sun. Sometimes they'd talk and once, they would fight. He remembers that day clearly. It was the end of summer and it seemed fitting afterwards that it would be the end of them, too. He accused her of being unfaithful. She quickly denied it; he thought too quickly and told her so. He now sighs and his eyes close. He no longer wants to think of this.

Three days later the girl zips up her suitcases. She cannot help but smile when she thinks of what the boy would say on seeing how full they are. But he is not here, and she will make herself forget. She lugs her cases down the stairs and is looking round for the final time when she hears a horn beep outside.

Sitting in the taxi she leans her head on the window. She pulls out her phone and locates the photos. She deletes quite a few. She wants no memories of him except one.
 She will even delete the goodbye text she taps out to him. And the reply, if there is one.

The message reaches the boy in his flat. He looks at it and then up at the clock. He knows her flight information; he checked with her friend. He looks back at the text. He let her go once; will he do it again? Making his decision he grabs the keys from a table, locks his door and runs to his car.

She is over three hours early as she checks her bags onto the flight. She decides to get a coffee before she boards the plane.

The boy knows he will not park. Instead, he ditches his car and runs.

The call has come to board and the girl hurries to the line with her passport in hand. As she gets to the man he asks for her boarding pass. She searches but cannot find it, and goes to the back of the line to look. A few moments later she hears her name and turns. She is shocked to see the boy standing there.
"Don't go. I love you," he tells her.
The girl pauses but says, "I can't do this now. I'm sorry I have to go."
She grabs her boarding pass out of the bag and gets on the plane.

It pours with rain that night, fitting to the boy's dark mood. He hears a knock at his front door, and reluctantly gets up to answer it. On opening the door he is shocked.

"Hi."

A bride walks up the aisle in a beautiful white dress. She stands at the altar where her veil is lifted. She smiles.

A baby cries to be cradled by her adoring mother and father.

A photo album is shut when a small voice comes from the kitchen.

"Mummy?"

As the mother makes her way out of the room, she pauses in front if the mantelpiece where a photo stands. The couple in it are smiling cheekily up at the camera and he has his arm draped around her shoulders in the picture surrounded by an oak frame. The woman looks back at her husband on the settee. She thinks of that night in the rain when she knocked on his door and smiles at how far the boy and the girl have come.

By Kate Coomby

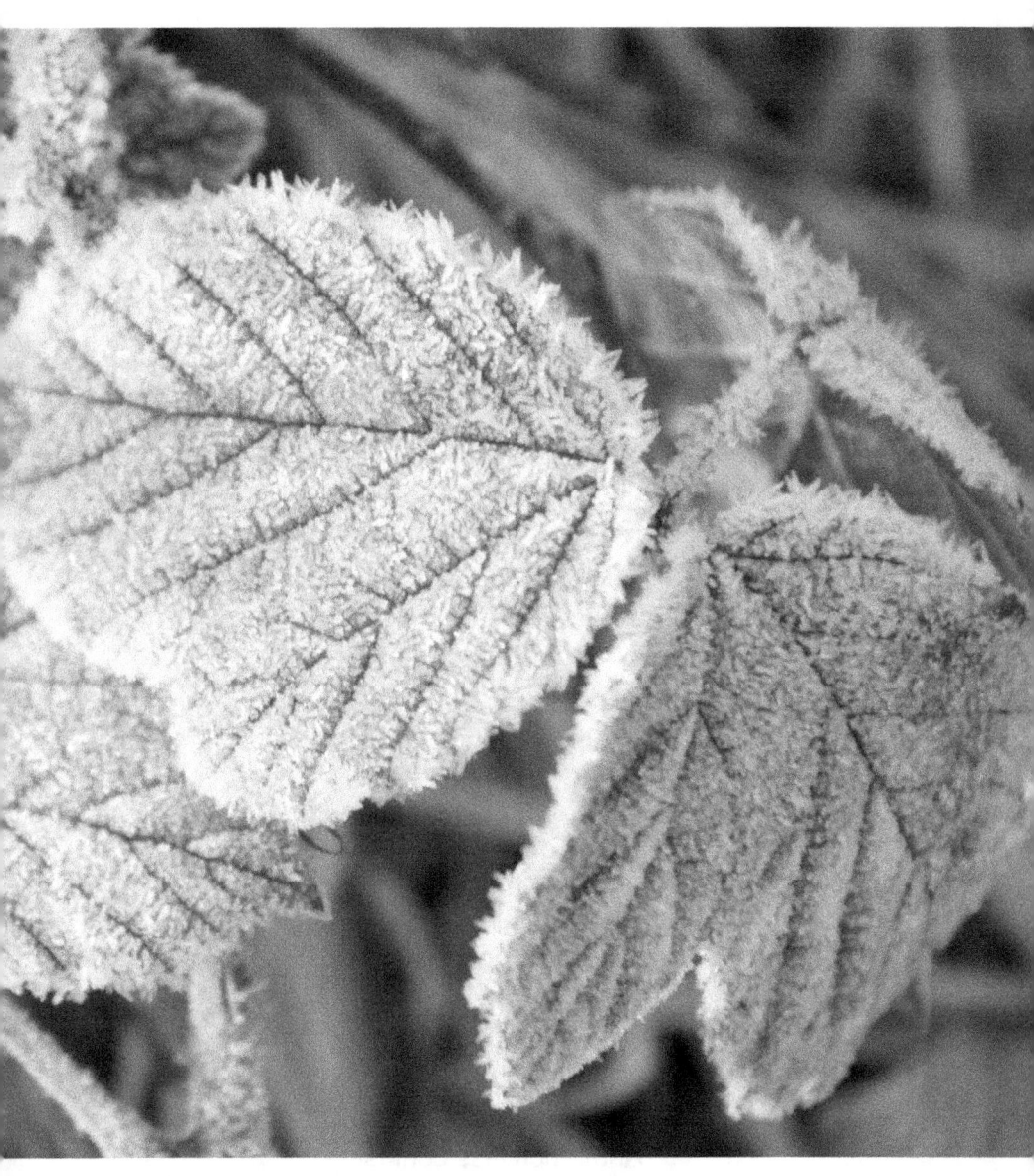

Frosted
By Amie Shaw

Journey

Let us set out from here
So that we may be friends
Long may the journey last
As friendship makes time fly
And we shall have the time
And all the world to fill

Where shall we visit first?
Who could we surprise most?
The poor man by the road
Or the rich man inside
Courts that princes favour
Or back streets that rats streak

In the dark, move quickly
Getting lost is easy
Only round one corner
Coming back the wrong way
Won't even need to say
We will already know

Keep near, that way at least
We won't lose each other
I'm sure a true friend is
Better than a compass
And much less confusing
Than a newly-bought map

By Philippa Marshall

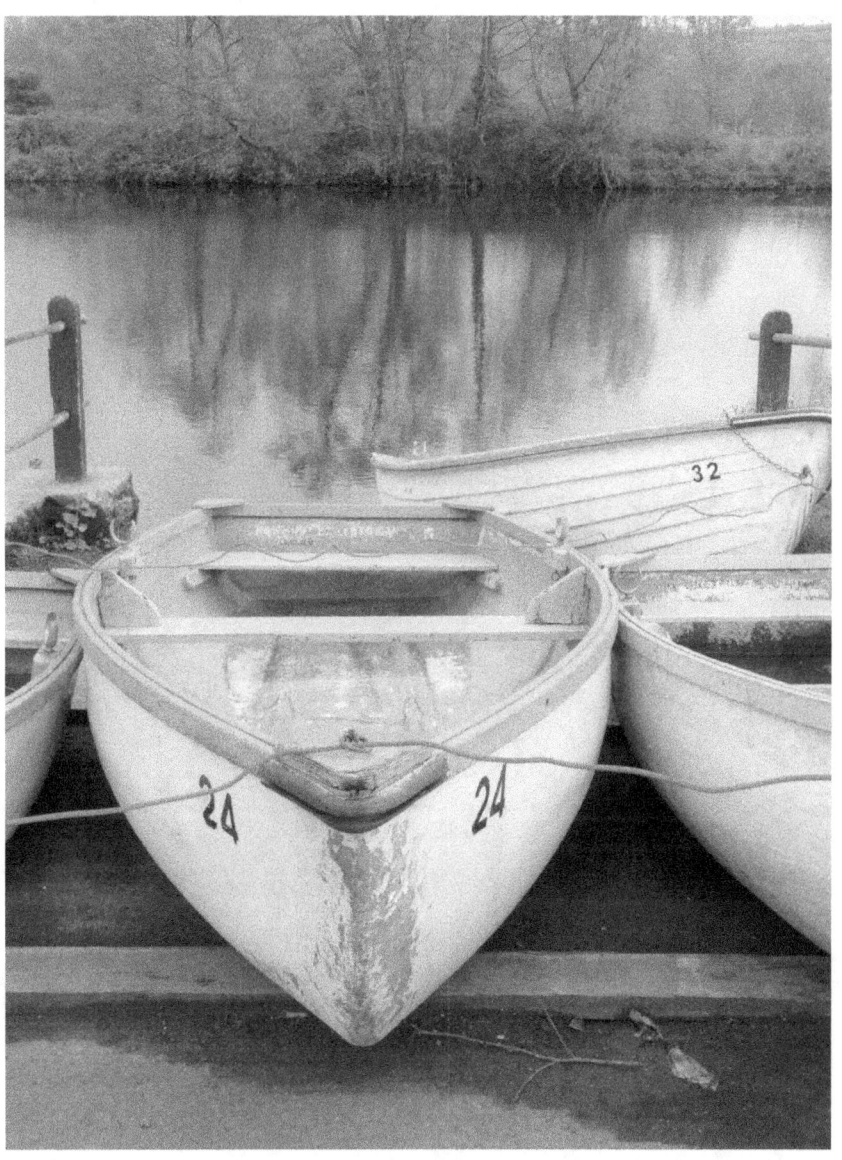

Down the Promenade
By Katie Stewart

Sleeping Girl
By Anna Cann

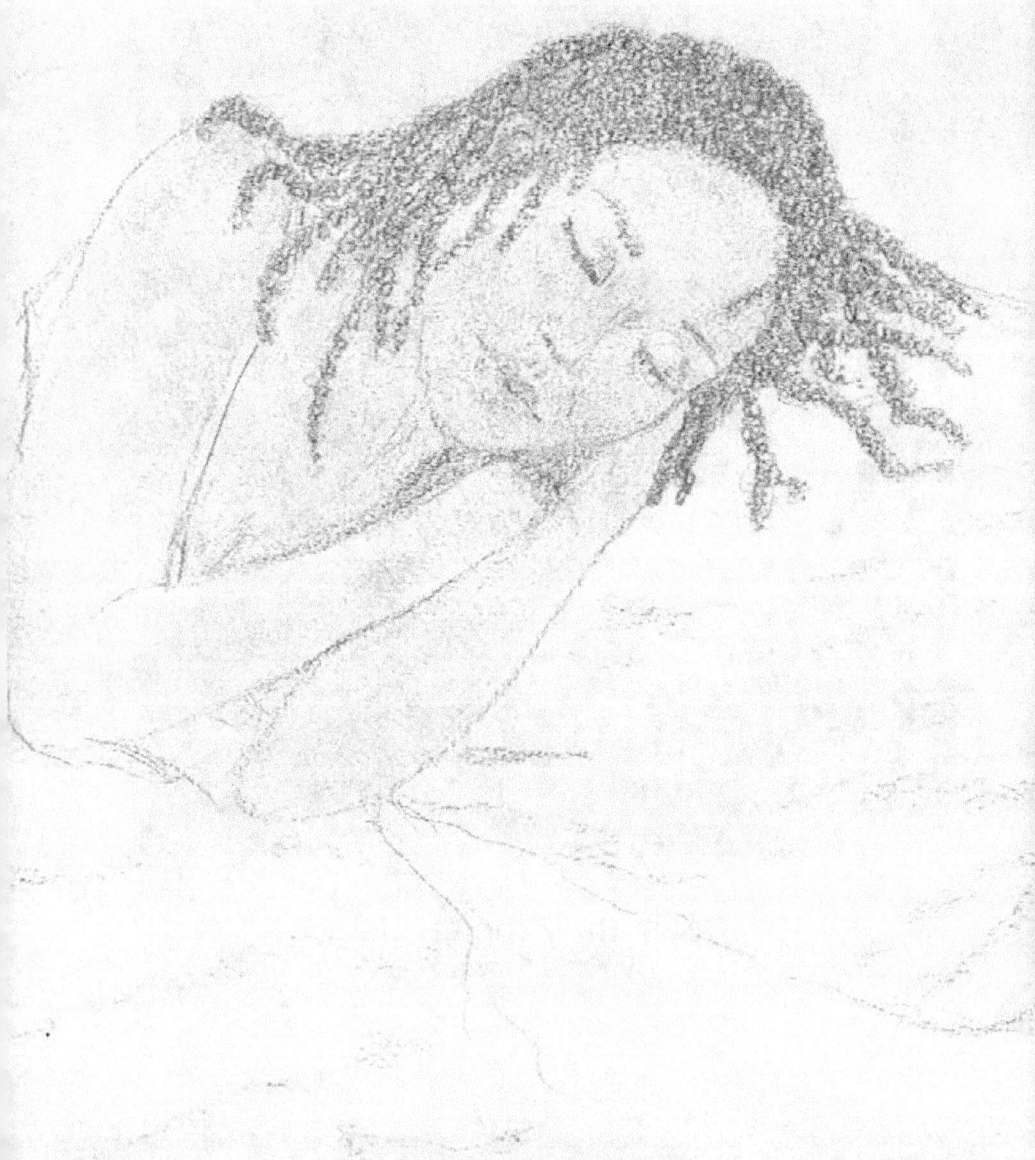

The Gift

A salt water river runs down
the cheek bones we shared.
Only I hear your laughter in the ripples of water.
The others see tears.
And it is only me who thinks the sunshine looks like your hair
that we shared.
Stars shimmer bright white in the midnight sky.
I find your eyes gazing back.
Don't cry.
The soft wind murmurs your name
as dawn kisses the sleep dust away.
You paint the morning with your colours: smudges of hazy dreams.
I light a candle.
Clouds cloak me in lilac smoke. I feel
the warmth of your body.
I trace your face in the sand at the beach;
sun blushed, rosy cheeks.
And they see my shadow, entwined
with your absence.
But I see the girl who sleeps.

By Eemaani Khalid

Ripples
By Emily Forward

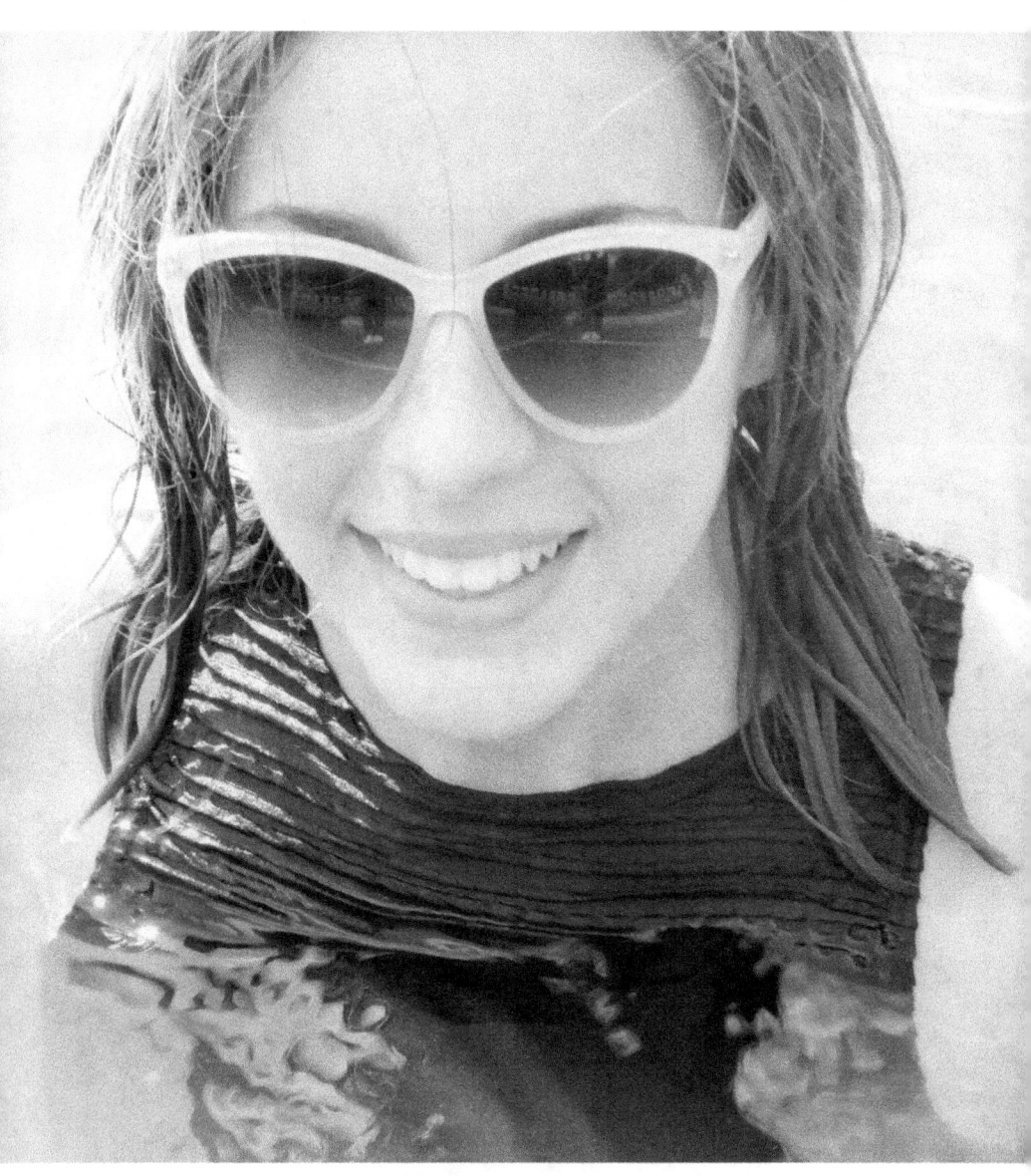

Chloé
By Brittany Gordon

Hello Caterpilly
By Brittany Gordon

Lego Adventure

'I like the way William puts me together, but I wish he would leave me in more comfortable positions,' said Mr Lego, moving out of the karate kick position.

'Me too,' answered Mrs Lego, getting out of her headstand. She looked around for Teenage Lego and Baby Lego. They were leaning happily against the wall of the Lego house.

'Today is the day I find the monster,' announced Mr Lego. They had been waiting for the humans to go out. Now all was quiet and the house silent. Mr Lego climbed down off the table, went to the Lego box and found himself a helmet and sword. He had heard the other Lego folk talking about the monster upstairs, and he intended to investigate. He ran across the floor to Tabby, the cat. She stretched, and yawned, and winked.

'Take me upstairs,' commanded Mr Lego, and jumped on Tabby's back. No one saw Teenage Lego follow him and catch hold of Tabby's tail. Tabby happily ran upstairs, Teenage Lego swinging to and fro like washing in the wind.

'I'll wait here,' purred Tabby. 'Just in case.'

Mr Lego walked bravely into one room. Teenage Lego sneaked through a gap in a different door, quiet as a mouse. High up on a table, he could see a glass tank.

'Lego people are strong and brave,' he told himself. 'I need to investigate.' He pushed some books together and climbed up to the tank.

'I wish my arms were longer,' he muttered as he reached for the top. 'I wish my legs bent at the knee,' he complained as he tried to climb on to the top. 'I wish I

had a parachute,' he moaned as he fell. In a corner lay Syd the Snake, fortunately fast asleep.

At that moment Mr Lego came into the room. He had heard Teenage Lego tapping softly on the glass. Syd had started to stir.

'What...? How...? When...? Stay there!' cried Mr Lego. He jumped on Tabby's back, and was back in the flick of a cat's tail, with a bag full of Lego bricks. He dropped them into the tank. Teenage Lego cleverly made them into a perfect staircase, from one side of the tank to the top, and ran up the steps.

Suddenly they heard the front door open.

'Still,' whispered Mr Lego. They both dropped to the floor like stones.

William, the human they belonged to, came upstairs to his room.

'Hey,' he exclaimed. 'How did that staircase get there? And how did you two get up here?' he asked picking up the Lego people. 'Tabby, have you been playing with my Lego again?'

Tabby yawned, and stretched, and winked.

By William Groom

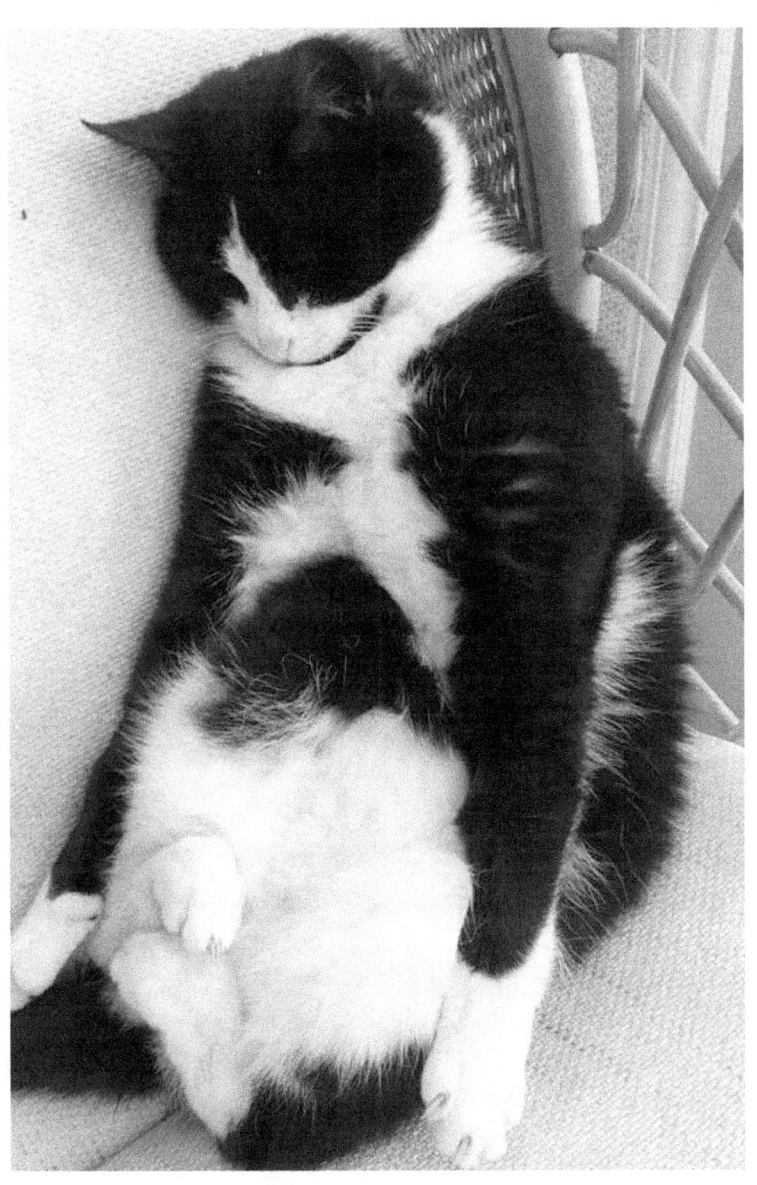

Sleepy Skye
By Amber Halstead

Steam Punk
By Jade Smith

Doctor Doctor...

Doctor doctor,
I don't feel right,
I've got bad fatigue,
I never get a good night,
Even when I do it doesn't get better,
All I want is to have the end in sight,
Because it's tearing away my life,
It's got a sharp bite,
Leaving me and many others,
Unable to do "normal" simple tasks,
Even such as washing, dressing and walking.

Doctor doctor,
My body's covered in pain,
It's there every day,
Why do I have to explain again?
These pills you give me,
The pain will still sustain,
They do not work.
Can't you just take it away?

Patient patient,
I've not really got a clue,
What you may have,
Seems to have come out of the blue,
I've done all the tests,
All come back oh phew,
It's good news,
There's nothing wrong with you.

Patient patient,
These symptoms due to,
Nothing we can find,

There is still one view,
You have chronic fatigue syndrome/ME,
And I've seen this before too,
So there you have a diagnosis,
Oh isn't that good for you.

So doctor doctor,
What are you going to do?
What has caused this?
How do I become like brand new?

Oh patient patient,
I really don't know,
What has caused this,
Or if it will grow,
And as for treatment,
Just follow the flow,
If you feel worse,
Just take it slow,
Nothing much I can do,
Or maybe although,
You could talk about your feelings?
That might help I really don't know.

By Stephanie Davies

Soapbox on Chronic Fatigue Syndrome/Myalgic Encephalopathy

Imagine if your world was flipped upside down. Imagine if you were so scared to leave the house, and if you did leave the house not having the energy to go anywhere. Imagine if you did something as simple as cry you would have to pay the consequences of being ill the next day, feeling like you had a bad case of the flu for simply crying. This is reality for young people with Chronic Fatigue Syndrome.

We don't want people to be overly sympathetic, don't pity and talk to us like we're a 5 year old. We are not generally ill, it is a condition both mentally and physically, with no treatment or cure. You have to learn to live with it and gradually work at it to increase your activity. But we do want some sort of support. Our brains are still as clever and the same as they ever were. The condition reduces the things we can do and how long we can do the activity for.

You can't see CFS, so it's difficult for people to understand that we're so ill. It's so obvious if someone has a broken leg, you can clearly see that they are not well or in some sort of pain. You would sympathize with them. CFS is invisible to people looking at us from the outside. We may look pale and be a little slower when walking but apart from that we look like everybody else. You probably think that we are pretending as you cannot

see it, but it's there; hence why no support is given to us. The sufferers of Chronic Fatigue Syndrome.

The culture of this country keeps a stiff upper lip. Grin and bear it. We are not brilliant when other people fall ill, especially when it goes on for a long time. Out of sight out of mind. We can be off school and nobody sees us for months without a single text or phone call heading our way from old friends or people we once knew. To begin with, it hurts a lot when this happens. You feel lonely and forgotten about, with only family to talk too. After a while some of us accept that we don't have any friends.

It's very unlikely you will ever get the chance to know how it feels for us on a day to day basis. Don't worry; we don't want you to feel guilty. You can't help us just like we can't magically make this condition disappear. Just please don't judge. Don't say you know how we feel because you don't. If you've ever had the flu, multiply it by 10 and that's what we live with every day and it can get a lot worse as we can get an ordinary bug on top of CFS as well, or just have really bad days when we have to be dragged out of bed. Even the slightest amount of movement can leave us stuck in bed for days. Sleep doesn't relieve it but the lack of it can make it considerably worse. Imagine if this happened to you. How would you and your family cope? Most of us are lucky in having supporting family but for those who do not, CFS could be an even worse nightmare. Just imagine...

By Georgina Wasdall

Forget M.E. Not

www.ingramcontent.com/pod-product-compliance
Lightning Source LLC
Chambersburg PA
CBHW070428180526
45158CB00017B/925